· JENNY ACKLAND ·

At Home with Shape and Size

· Oxford University Press ·

How to help your child

- Choose a quiet time to sit together, when your child is not tired or distracted.

- Work in short periods of activity, and stop as soon as your child loses concentration.

- Talk through the activities with your child, so that he or she develops the language to describe shapes, and patterns, and size.

- Apply these descriptions to objects around the home, so that your child realizes that mathematics is very much a part of everyday life.

- Give plenty of praise and encouragement.

- Remember that the workbook should be fun for your child, as well as being educationally worthwhile.

About Shape and Size

The process of learning about shapes, and patterns, and size involves all of the following skills:

- visual discrimination between different shapes, patterns, and sizes
- hand–eye coordination in filling in patterns
- recognition of continuing patterns and sequences
- three-dimensional awareness, of shape in space
- developing a vocabulary to describe shape and size
- estimation of differences in dimensions
- early measurement

Further notes on the individual sections are provided on page 48.

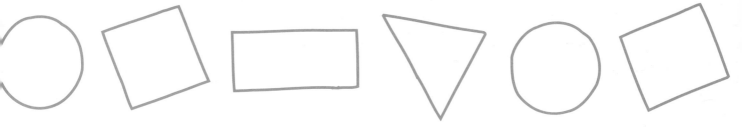

• CONTENTS •

Join up the same

Colour the same shape the same colour

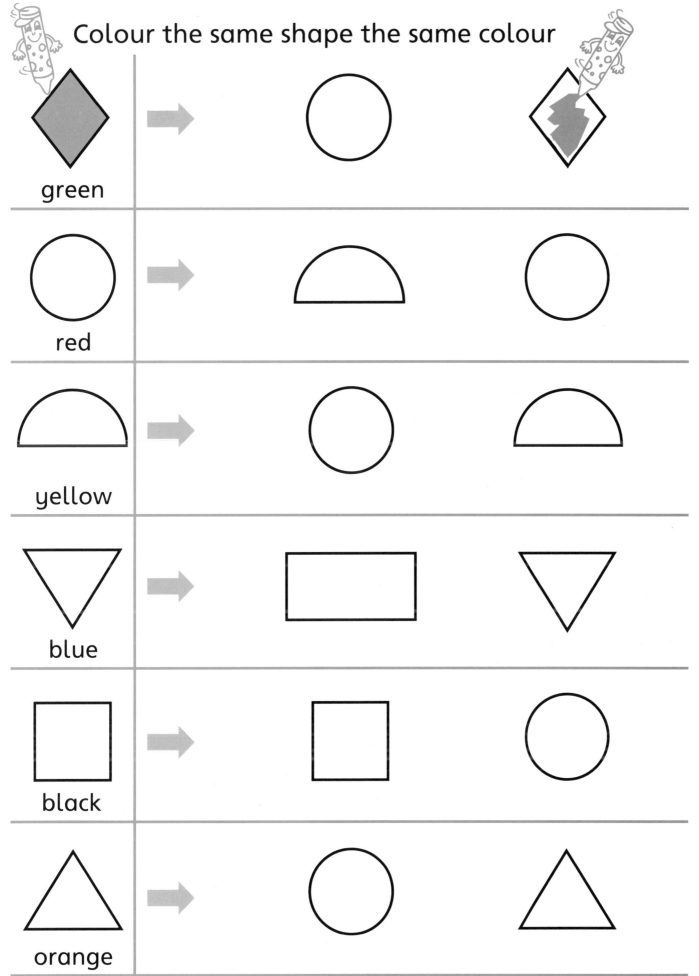

green

red

yellow

blue

black

orange

Ring the same shapes

Find two more the same. Colour the same colour

green

red

blue

yellow

orange

brown

blue

green

Join up the same

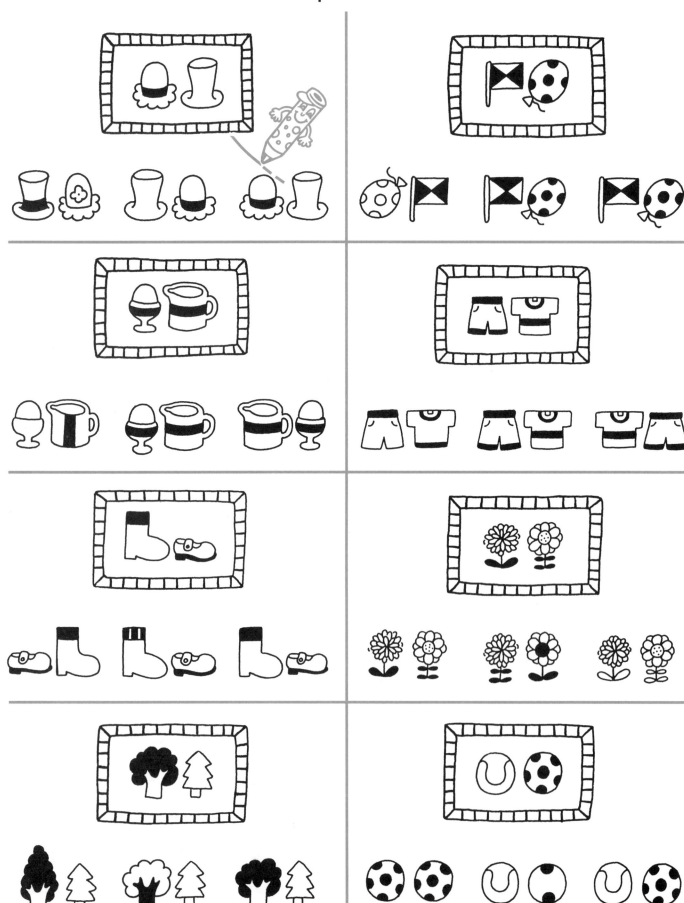

Join up the same

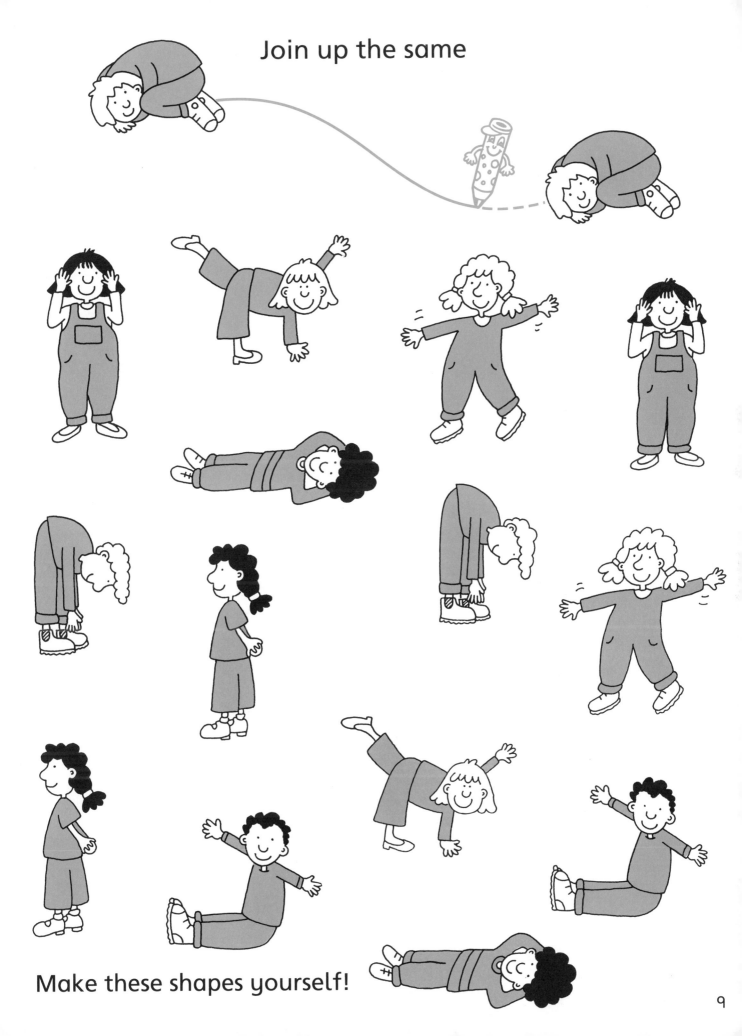

Make these shapes yourself!

9

Join up the same pattern

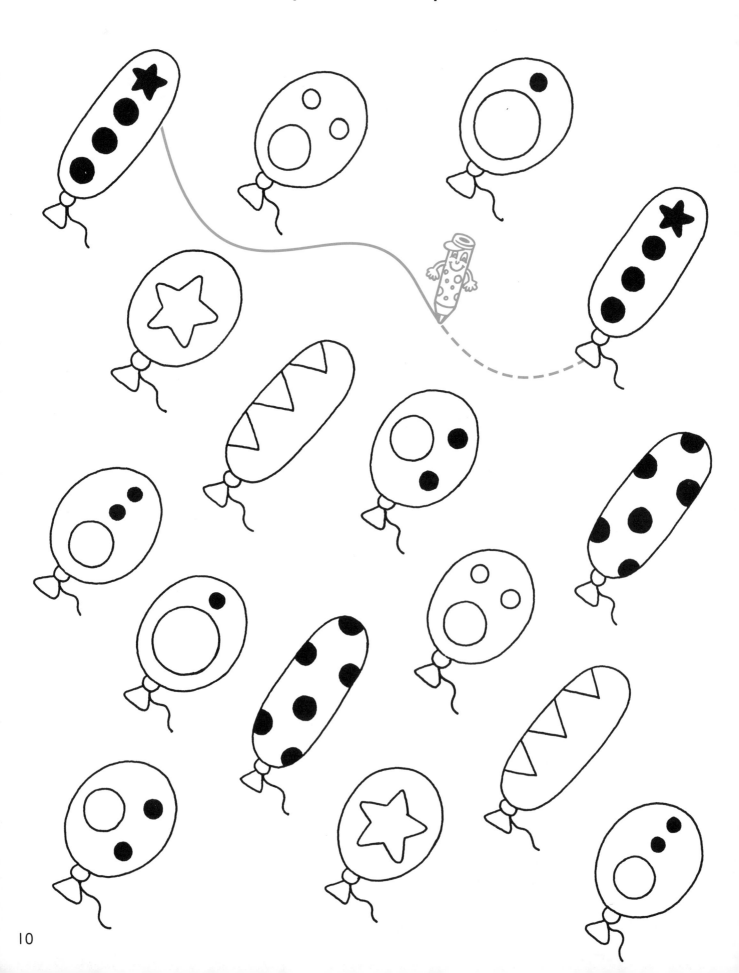

Join up the same pattern

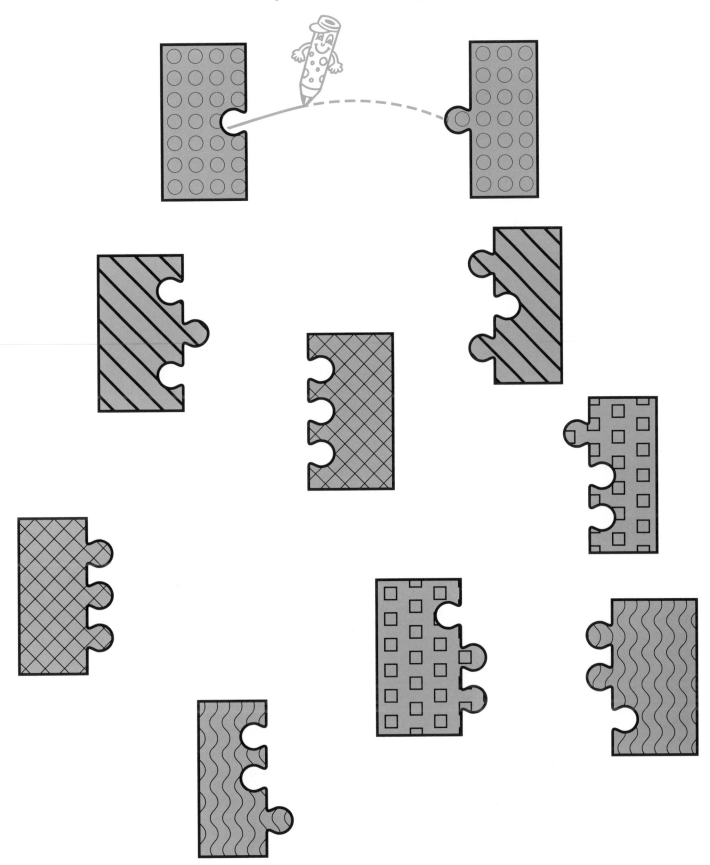

Do the shapes also fit together?

Which goes with the set?

Which goes with the set?

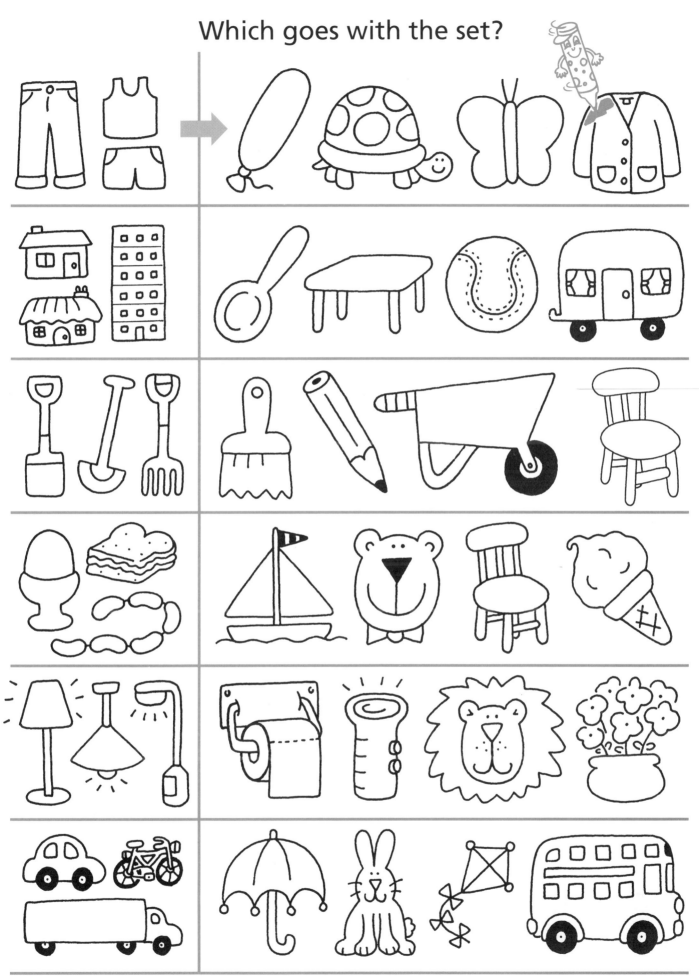

Odd one out

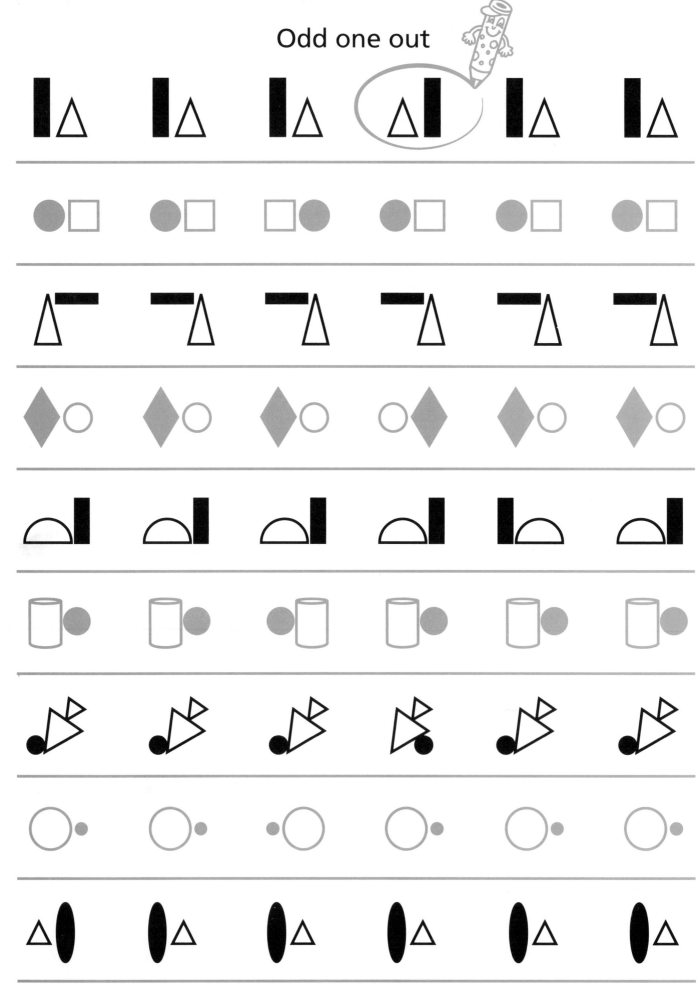

Odd one out

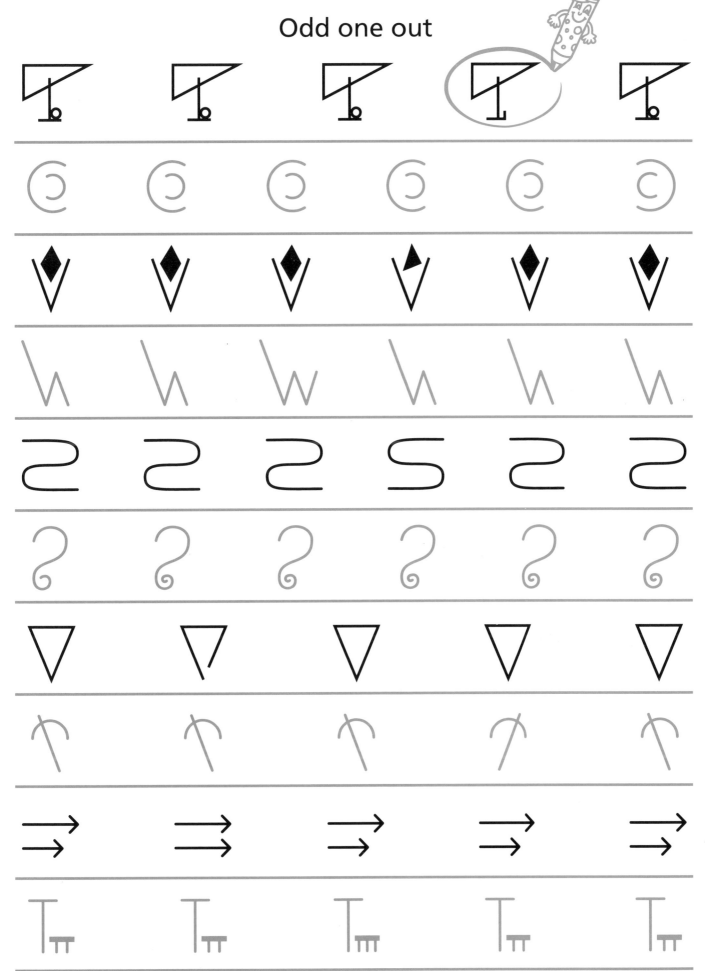

Odd one out

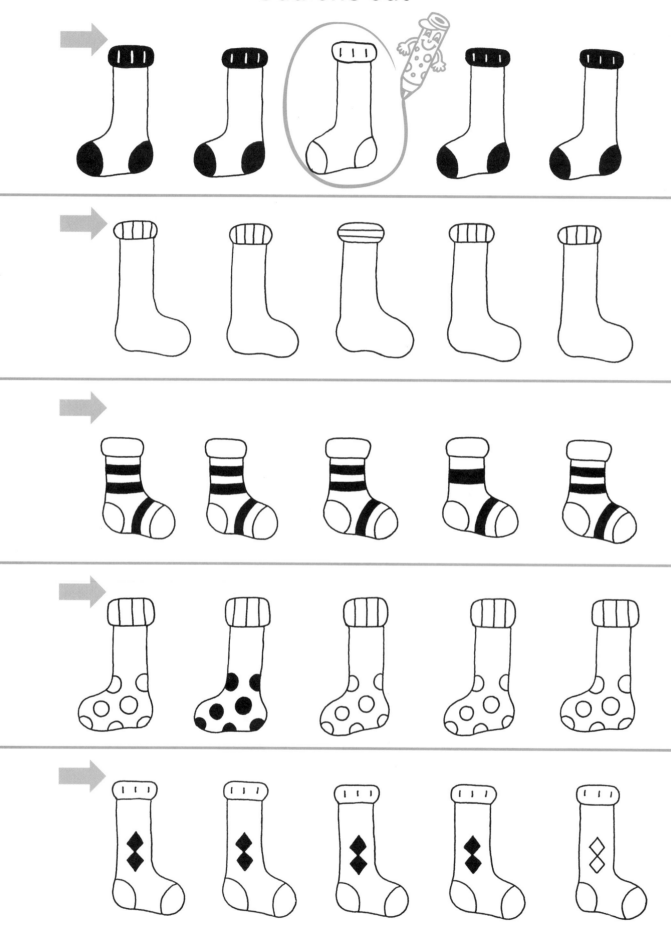

Odd one out

Make the same

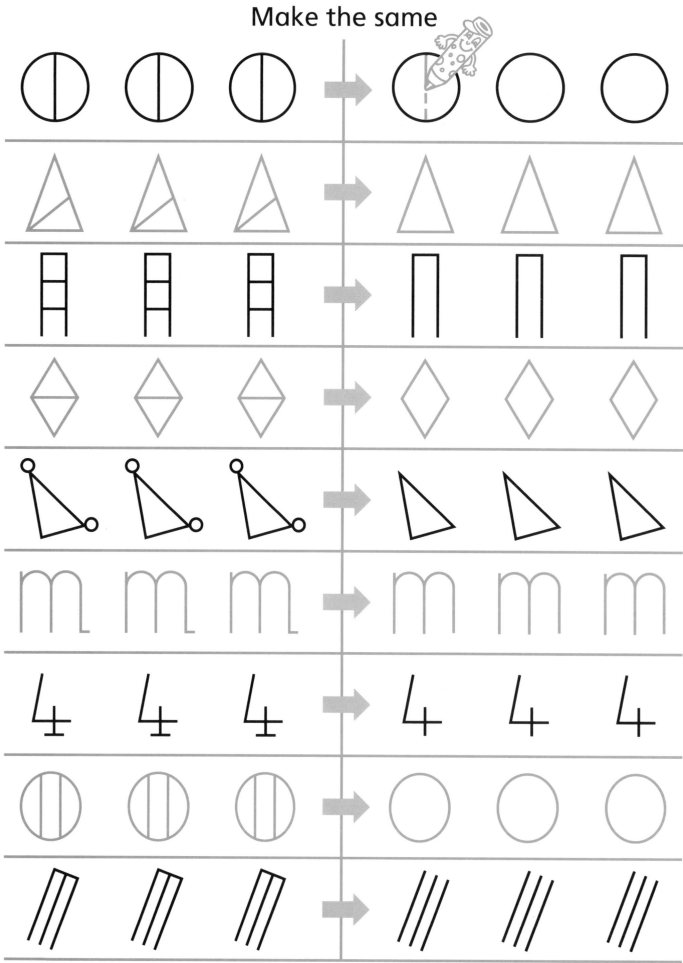

Make the same

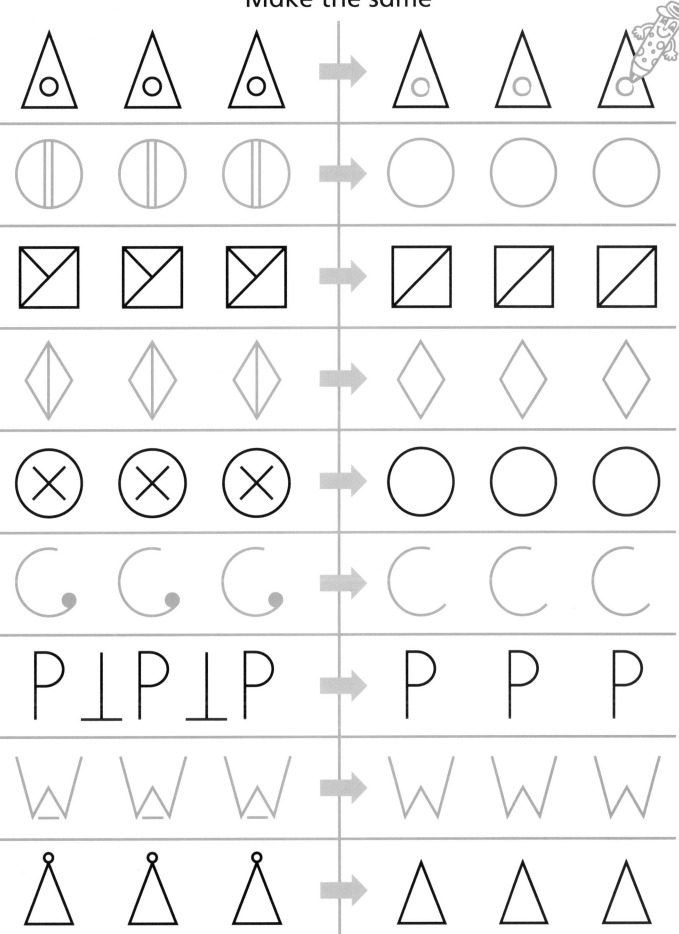

Make the same

Make the same

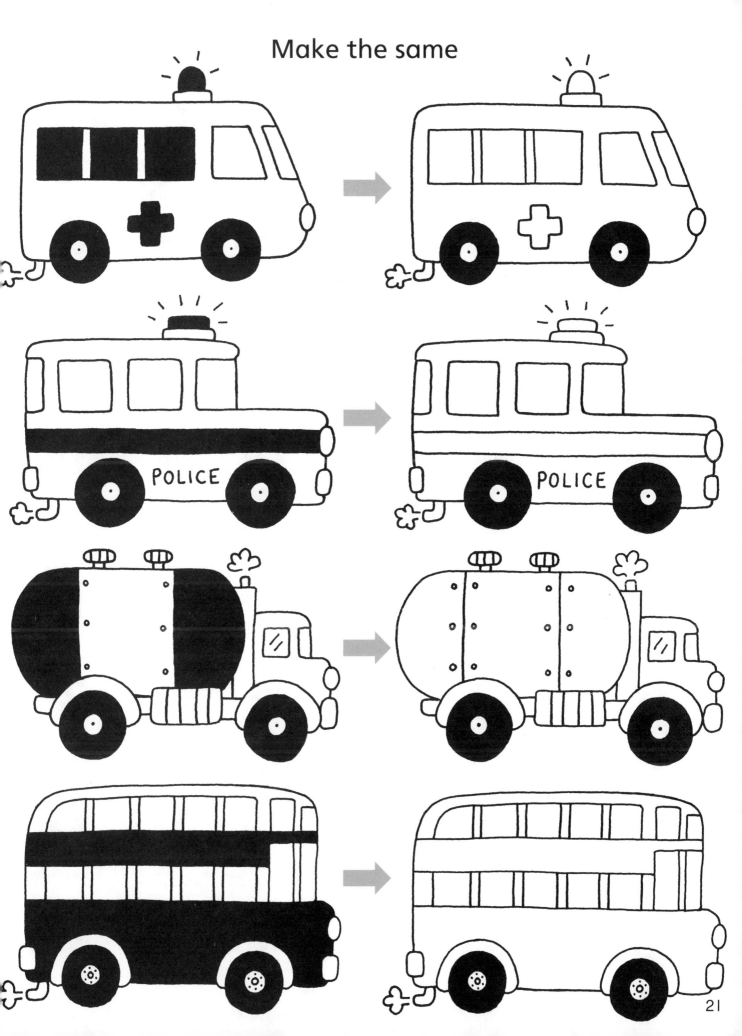

What comes next?

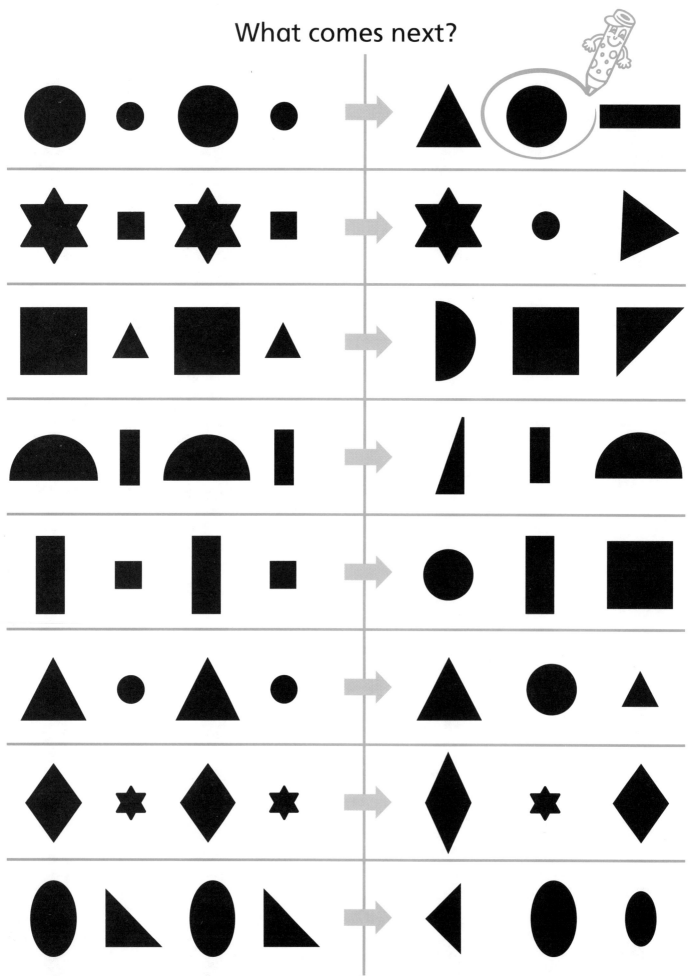

What comes next? Colour the pattern

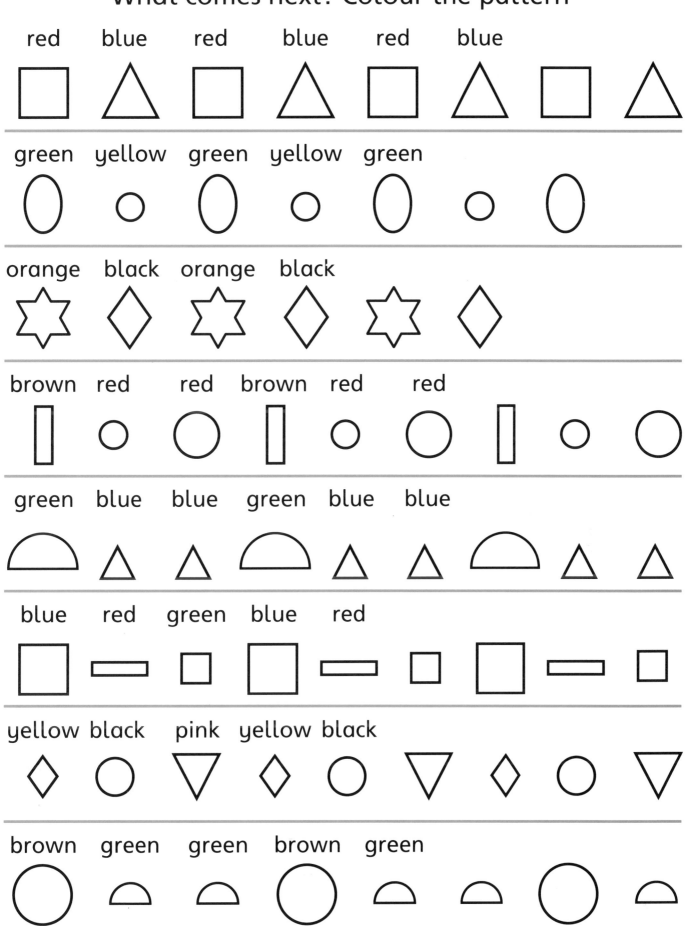

red blue red blue red blue

green yellow green yellow green

orange black orange black

brown red red brown red red

green blue blue green blue blue

blue red green blue red

yellow black pink yellow black

brown green green brown green

23

Colour the squares ☐ ☐ yellow.

Colour the circles ◯ ◯ blue.

Colour the triangles △ △ green.

Colour the △ △ △ orange. Colour the ◇ ◇ blue.

Colour the ○ ○ yellow. Colour the ▯ ▯ black.

Colour the ▢ ▢ ▢ green. Colour the ⌣ red.

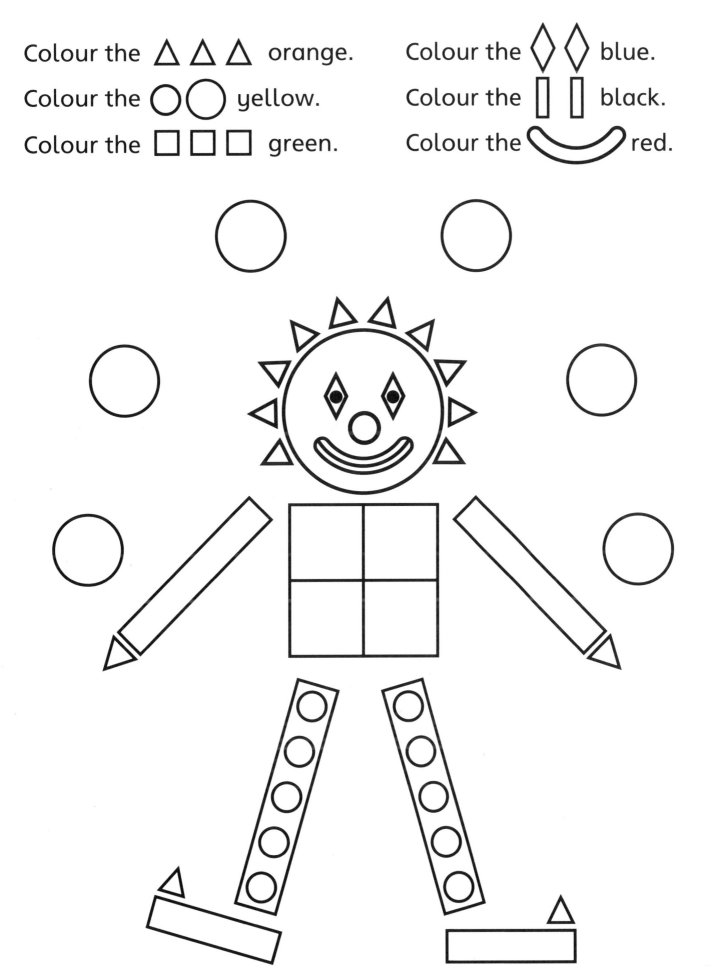

Colour all the circles red.
Colour all the squares yellow.

26

Colour all the semi-circles green.
Colour all the triangles blue.

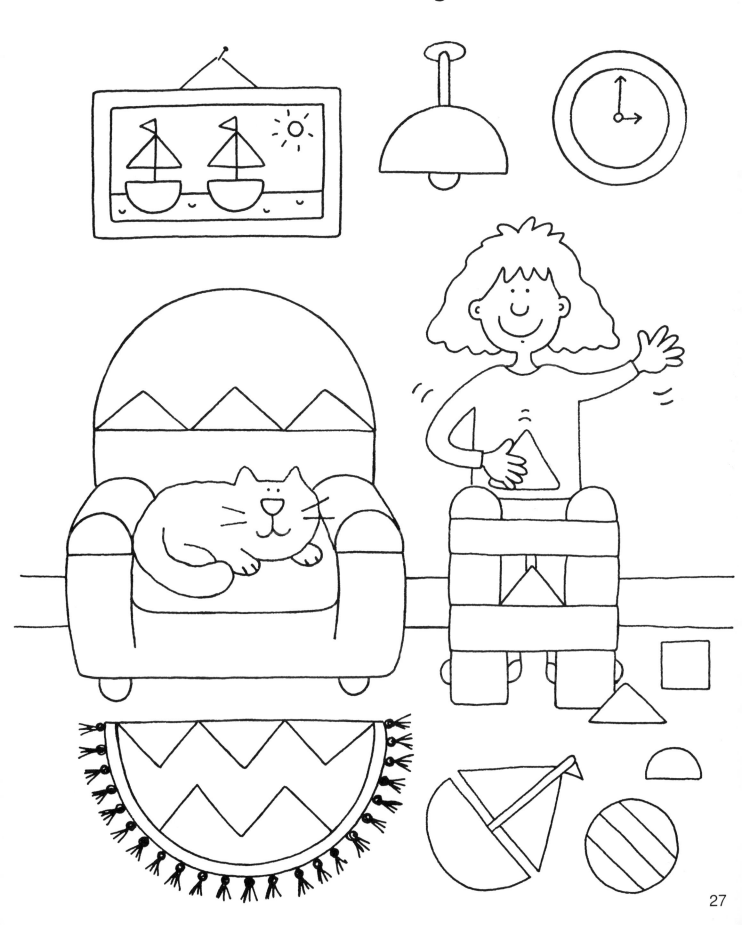

27

Straight Curved

 straight **curved**

 straight curved

 straight curved

 straight curved

 straight curved

 straight curved

 straight curved

 straight curved

1 4 7 straight curved

3 6 8 straight curved

 straight curved

 straight curved

Zigzag

Spiral

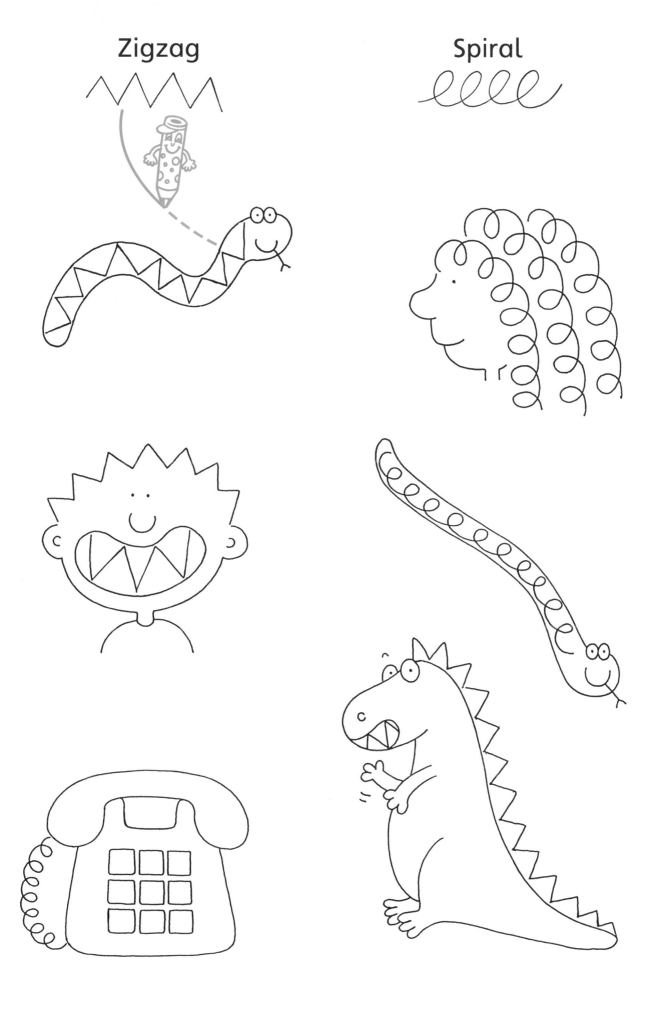

Colour the same size

green

orange

red

blue

green

yellow

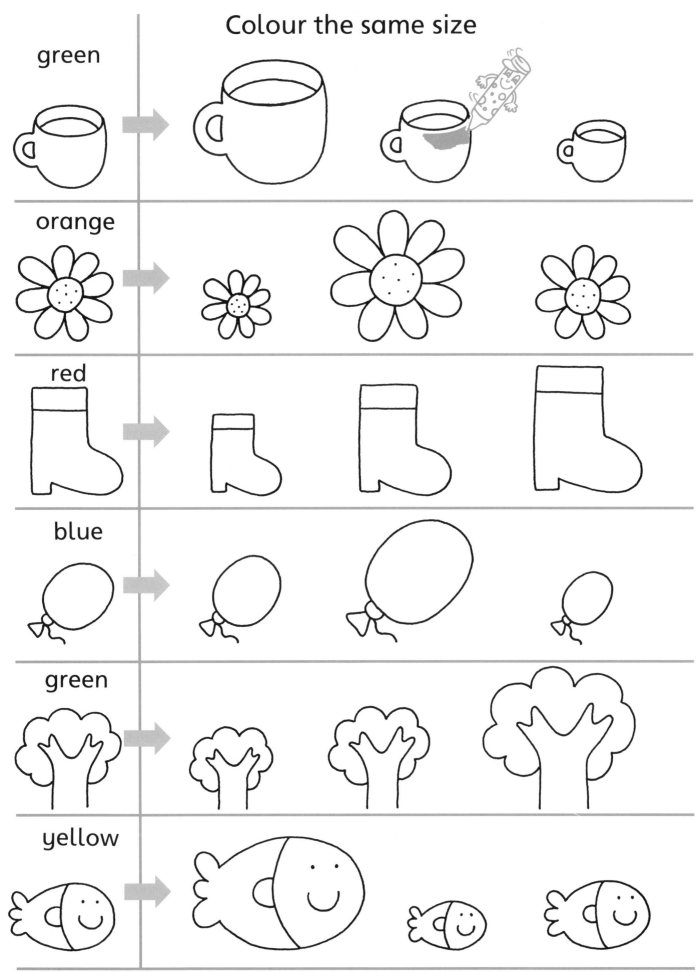

Colour the same size

orange

brown

red

green

black

yellow

blue

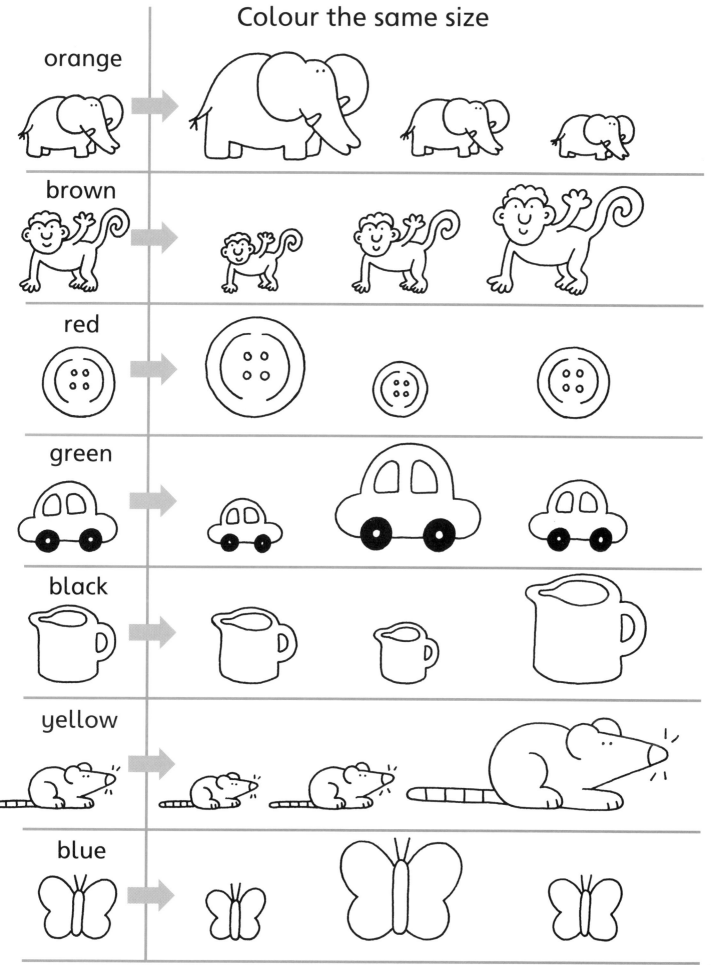

Colour the same size

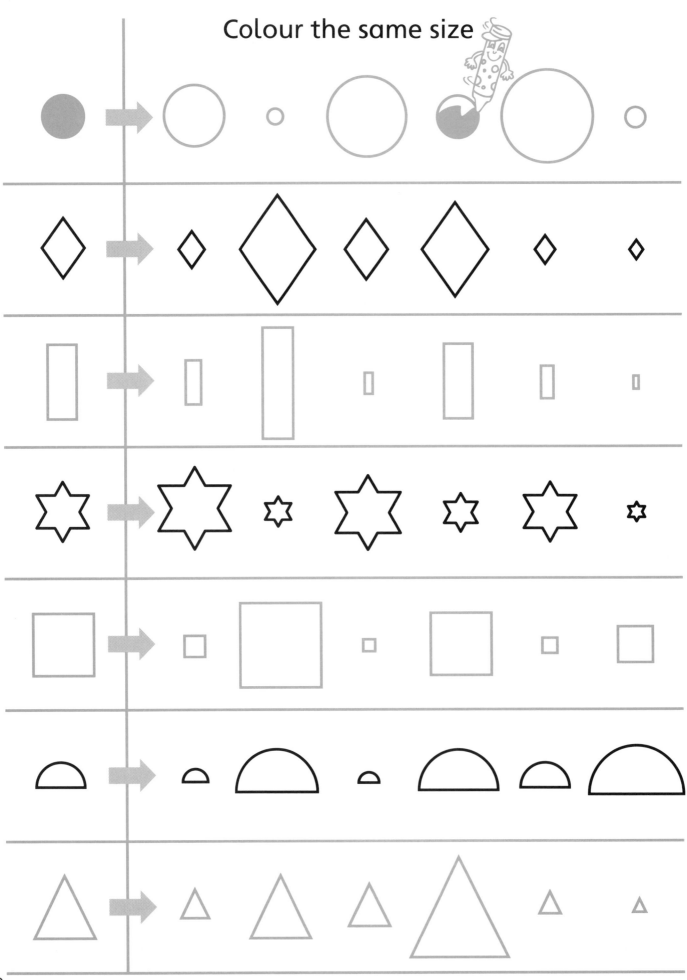

Join up big and little

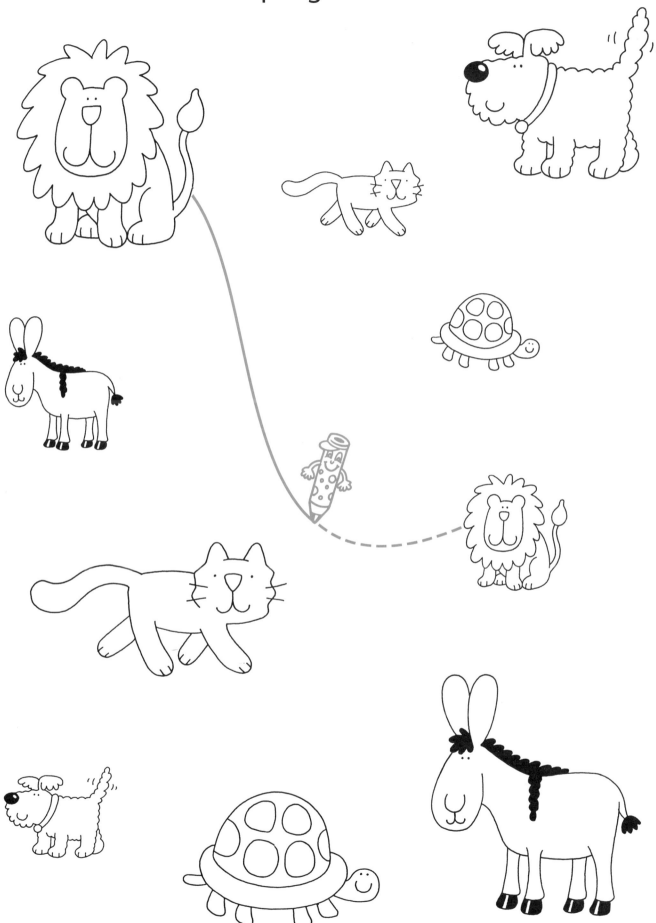

Colour the big ◯ red.
Colour the little ○ blue.
Colour the big ☐ green.
Colour the little ☐ yellow.

Colour big and little

Colour the big fish orange.
Colour the little fish green.

Colour the big tree brown.
Colour the little trees red.

Colour the big car black.
Colour the little cars yellow.

Colour the big motor-bike blue.
Colour the little motor-bikes pink.

Colour the big balloon red.
Colour the little balloons pink.

Colour the bigger one

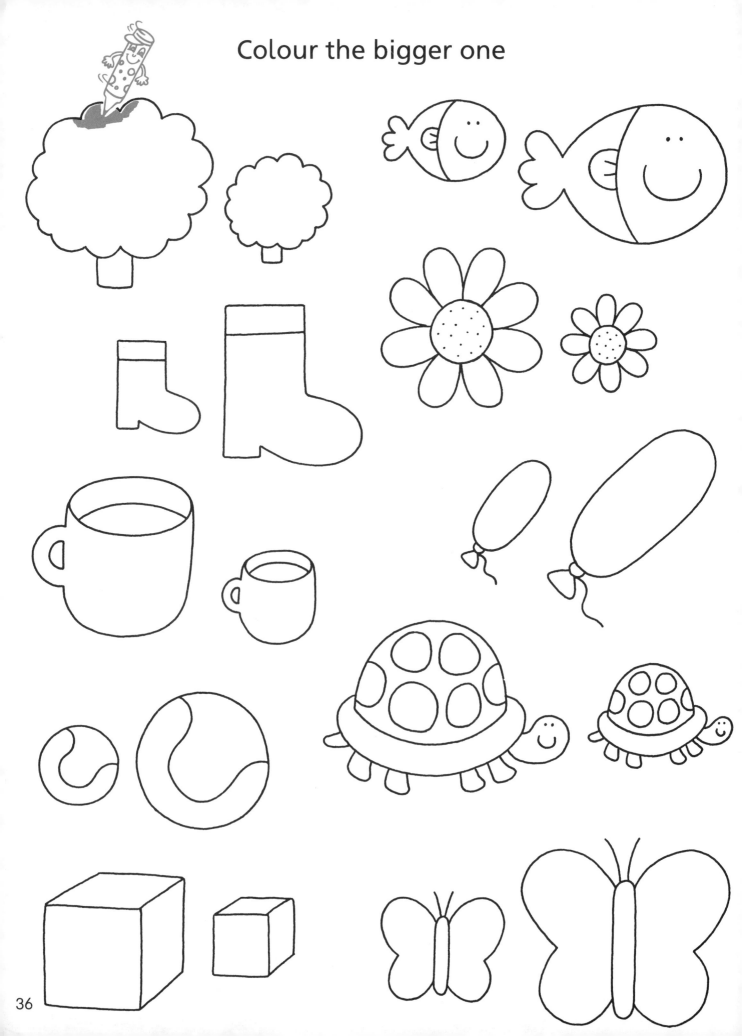

Colour the smaller one

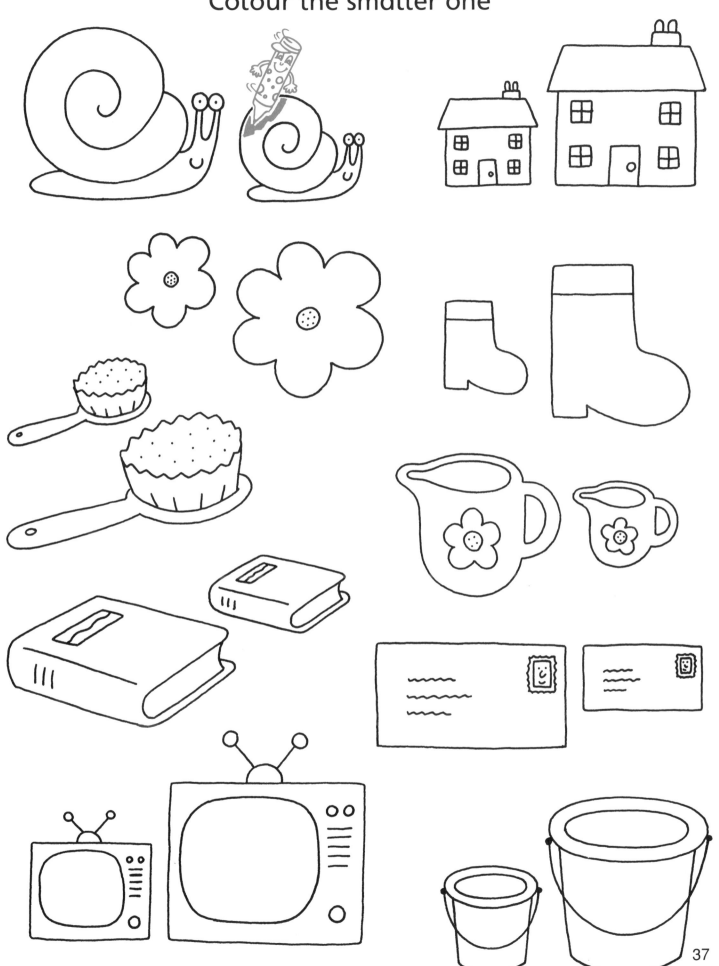

Colour the biggest one

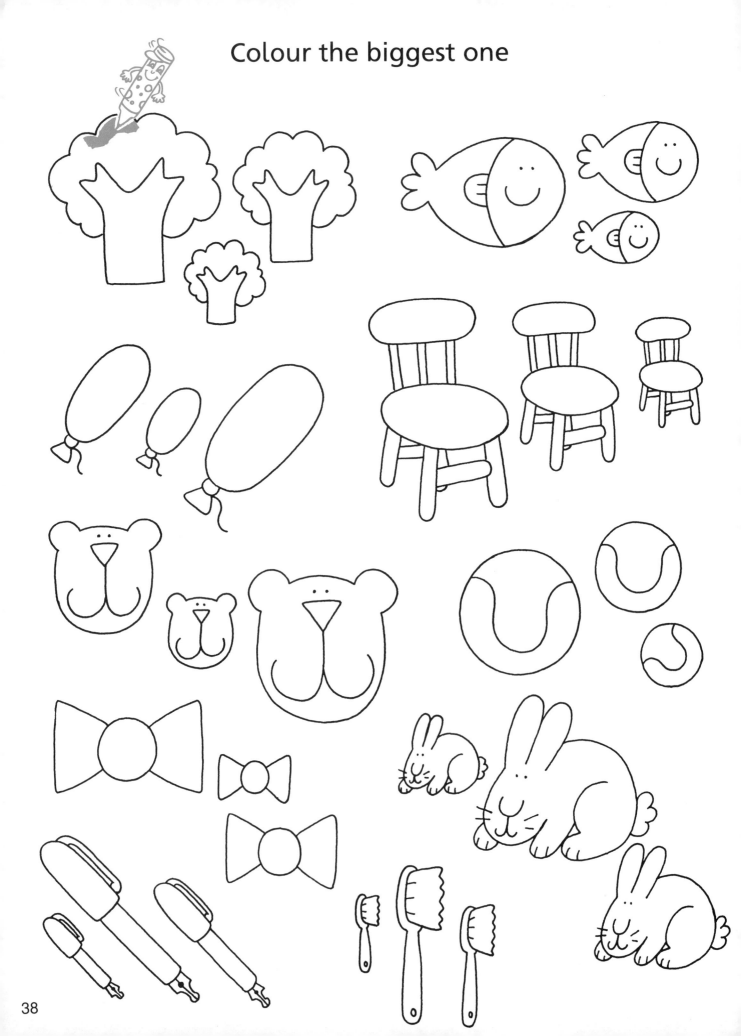

Colour the smallest one

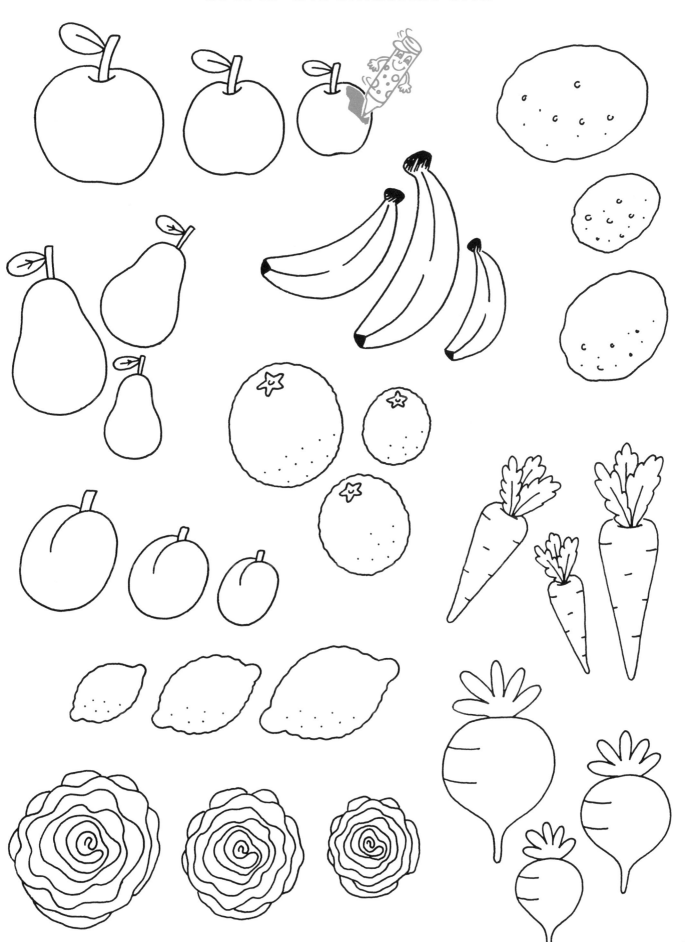

Colour the same height

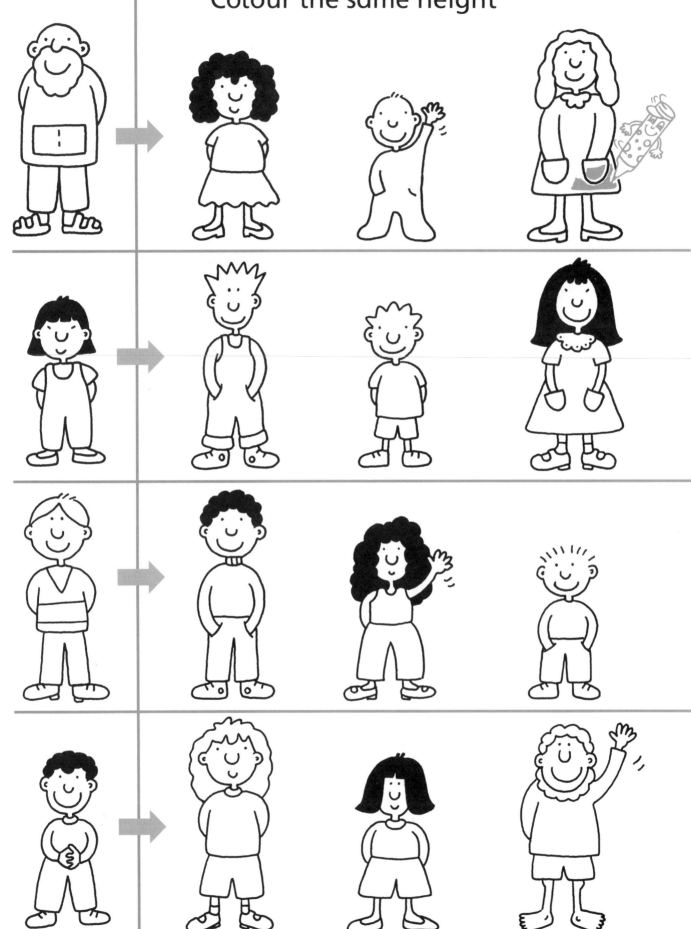

Which two children are the same height?

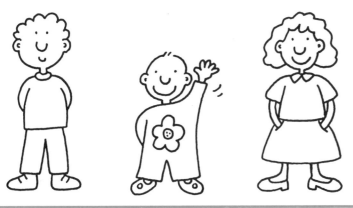

Colour them red.

Which two trees are the same height?

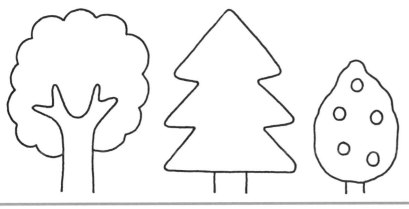

Colour them green.

Which two houses are the same height?

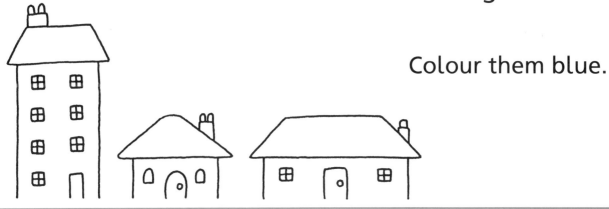

Colour them blue.

Which two sunflowers are the same height?

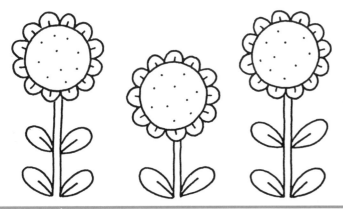

Colour them yellow.

Colour the shorter flower

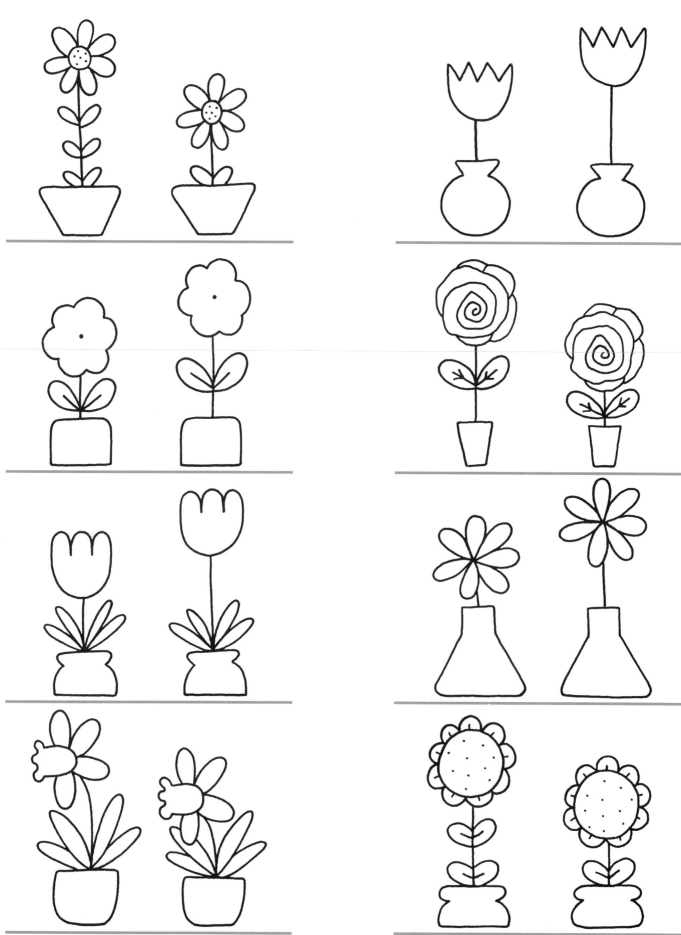

Colour the tallest one red.
Colour the shortest one blue.

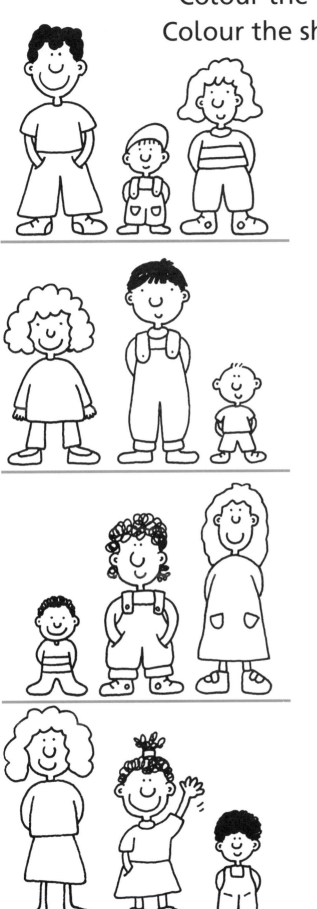
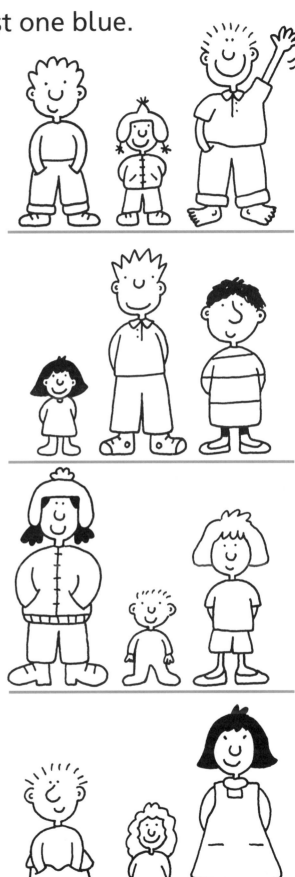

Colour the longer train red.

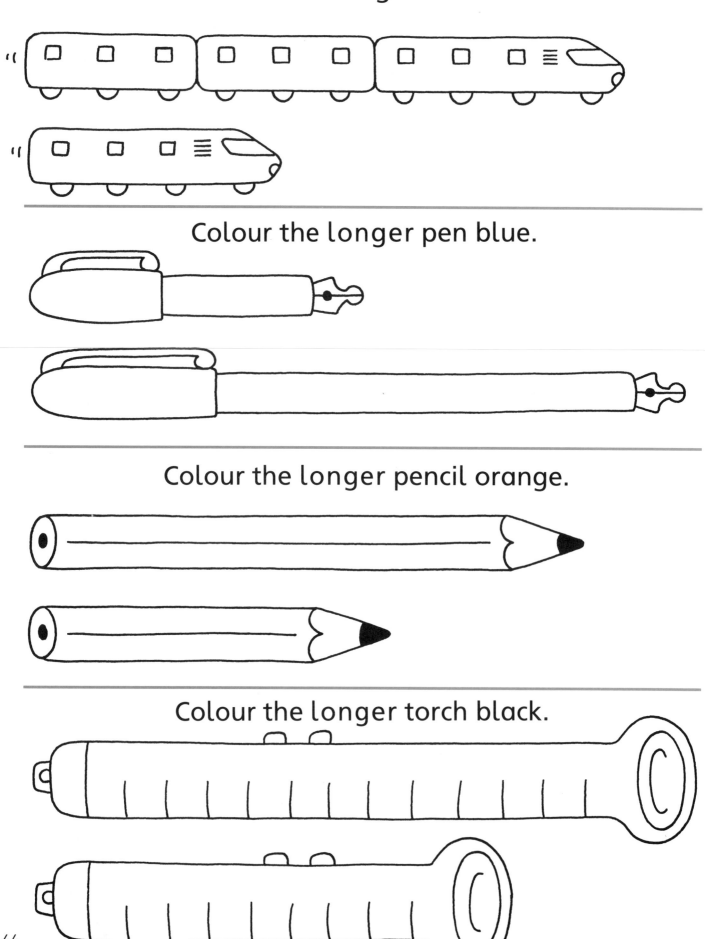

Colour the longer pen blue.

Colour the longer pencil orange.

Colour the longer torch black.

Colour two the same length

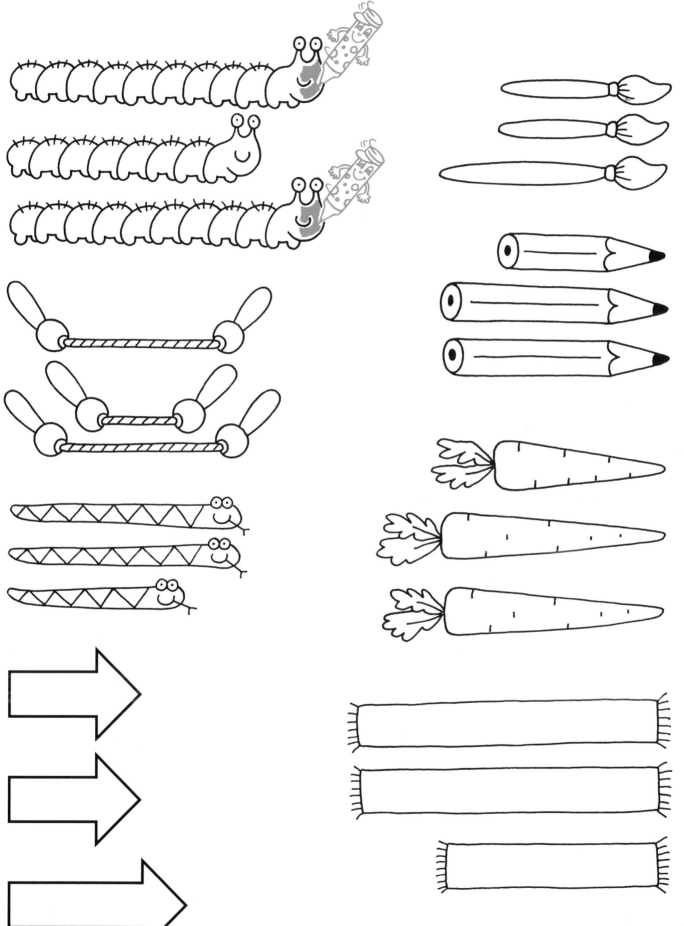

Colour the fattest one black

Colour the thinnest one green

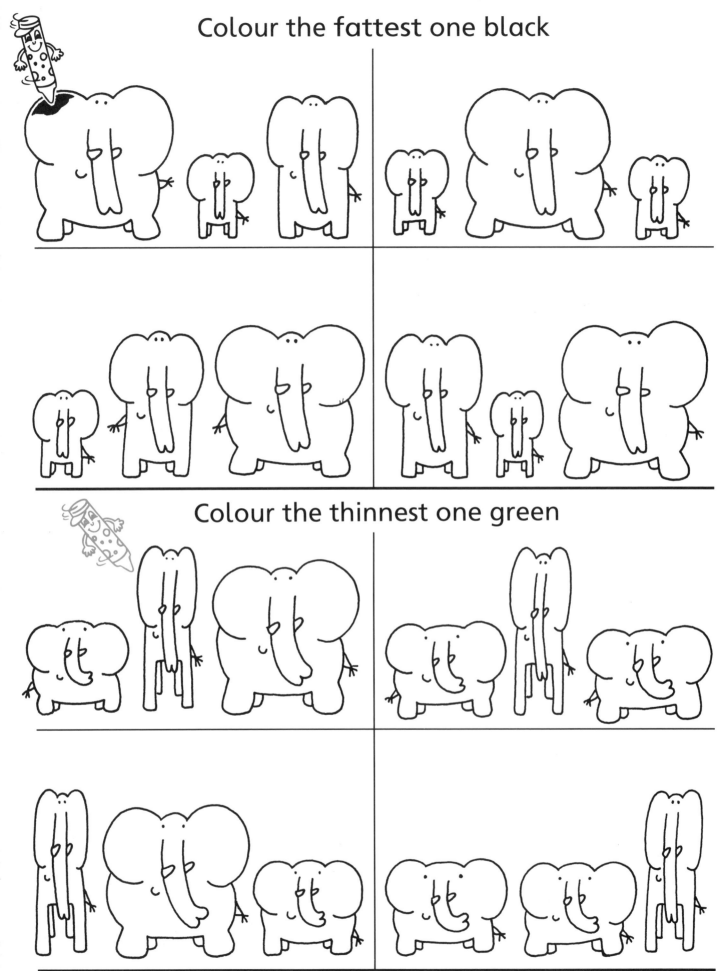

Draw a bigger circle than this.

Draw a smaller circle than this.

Draw a longer line than this.

Draw a shorter line than this.

Draw a taller boy than this.

Draw a shorter boy than this.

Draw a fatter cat than this.

Draw a thinner cat than this.

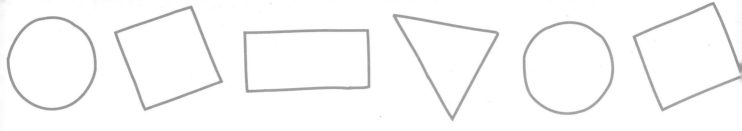

Notes for parents

Find the same pp. 4–13 This section helps children to recognize similarities of both shape and pattern. The names of the shapes are not important at this stage: the child is simply practising visual perception and discrimination.

The idea of sets, at the end of the section, is a basic mathematical concept: that objects can be classified together, by shape, or colour, or any other kind of function.

Odd one out pp. 14–17 From similarities, we proceed to differences: here the child has to spot the difference, in either shape or pattern. Again, this is good for visual discrimination.

Make the same pp. 18–21 This section bridges the gap between similarity and difference: spotting the difference, and then making the pattern or shape the same as its counterpart.

What comes next? pp. 22–23 This time the child is looking at a sequence of shapes, and establishing the pattern of repeats. It helps to point to each shape and say its name aloud, so that the child can hear the rhythm of the repeating pattern.

Name the shape pp. 24–29 By this stage it is worth the child learning the names of geometrical shapes: starting with flat shapes like squares, circles, triangles. Help your child to look around the home and find these shapes in everyday objects. They should also learn to describe the features of different shapes, with adjectives like straight, curved, spiky, jagged etc.

Big, bigger, biggest pp. 30–39 We now progress to comparison of size, first of all comparing bulk: big and little, and big, bigger, biggest.

Tall and short pp. 40–43 This is the vertical dimension of size: tall and short, as applied to people, flowers, trees etc. Again, you should practise finding real objects around the home to compare in height.

Long, longer, longest pp. 44-47 This section further develops the vocabulary of size: helping the child to talk about linear dimensions, as long or short. This ability will lead into further mathematical skills, of estimating and measurement.

Oxford University Press
Great Clarendon Street, Oxford OX2 6DP

Oxford New York
Athens Auckland Bangkok Bogota Buenos Aires
Calcutta Cape Town Chennai Dar es Salaam Delhi
Florence Hong Kong Istanbul Karachi Kuala Lumpur
Madrid Melbourne Mexico City Mumbai Nairobi Paris
São Paulo Singapore Taipei Tokyo Toronto Warsaw

and associated companies in
Berlin Ibadan

Oxford is a trade mark of Oxford University Press

© Jenny Ackland 1993
First published 1993
Reprinted 1993, 1994, 1996, 1997 (twice), 1998 (twice)

ISBN 0 19 838118 2

Designed by Oxprint Ltd, Oxford
Illustrations by Sue Cony
Printed in Hong Kong